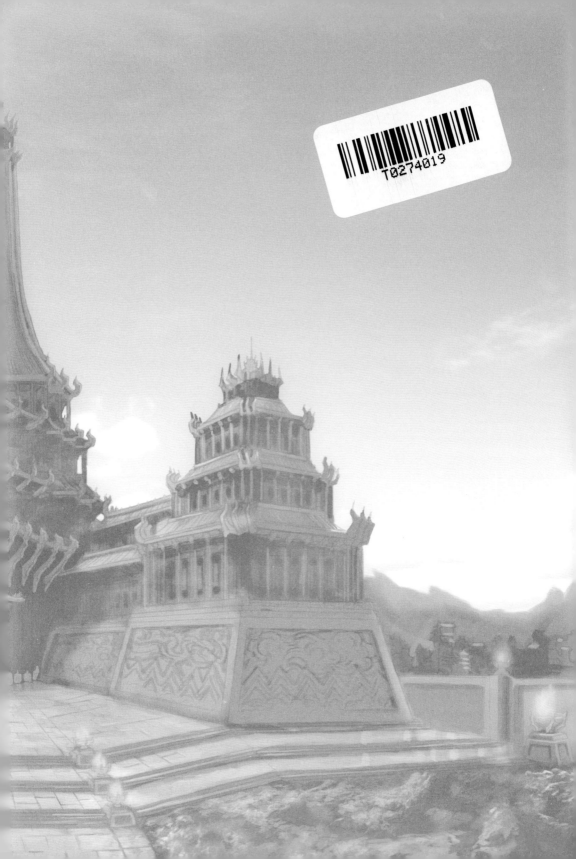

第壹國皇家地圖

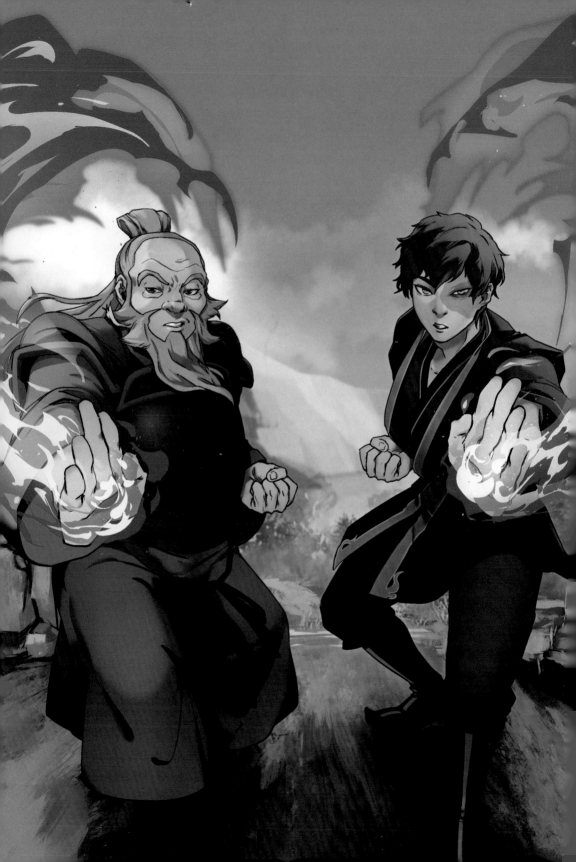

LEGACY of the FIRE NATION

CREATED BY

BRYAN KONIETZKO
MICHAEL DANTE DIMARTINO

TEXT BY

JOSHUA PRUETT

ORIGINAL ILLUSTRATIONS BY

SORA MEDINA

INSIGHT
EDITIONS

San Rafael · Los Angeles · London

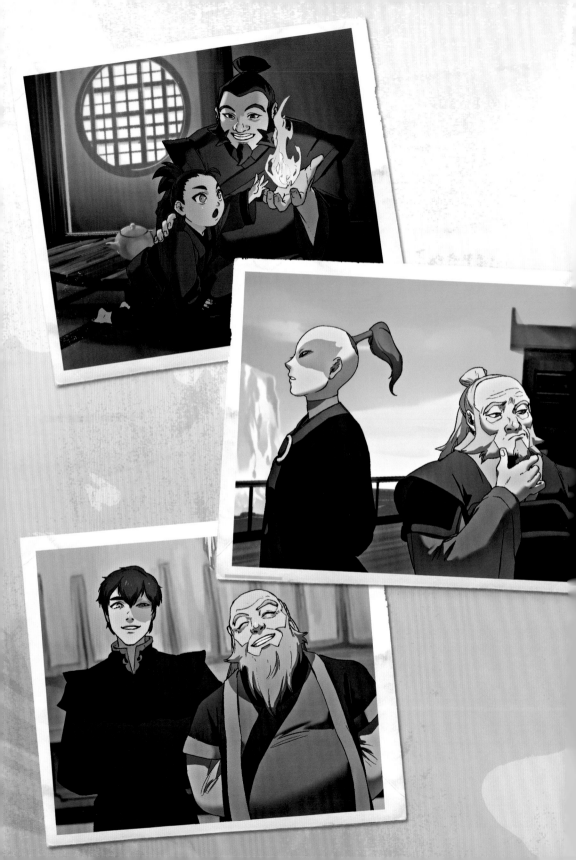

A GIFT FOR ZUKO

My dear Prince Zuko,

 The following pages are my gift to you, my prince. They are part letter, part memory book, and while they may certainly benefit from some trimming, these pages represent the truth, at least as I saw it and experienced it. At worst, they're a place for an old man to catch his thoughts before they leave his head like ashes on the wind, and to pass on to you all that I have learned. I'm calling it <u>Legacy of the Fire Nation</u> or <u>Old Iroh's Guide to Pai Sho and Other Nonsense</u>. I'll let you pick the title. You will notice that I may ramble on at times, and that there will likely be parts of it that you skip or get bored by, but in my experience, you're only ready to hear what you are ready to hear when you are ready to hear it. So just hush and listen, nephew. I hope these pages remind you of my voice and my presence, for you know I will always be with you. I hope I can give you the benefit of my years, what my eyes have seen, and what perspective I have gained, and more importantly, what my heart has felt. An old man has little to hold in his hands during his last days but much more in his heart than he can carry. I don't want this to be a burden. Instead, I pray that it will be a comfort. I want this to be a gift for you, my prince. Most knowledge must be earned, but if I'm lucky, the passages in this book will allow you to borrow my knowledge and aid you in making good choices and owning your experiences. Know that I am always thinking of you, and that by gifting you my story, I only hope to add to yours and the family I hope you one day make for yourself. Now, get reading. If you don't, I'll come back as a grumpy spirit and haunt you! Only joking. Kind of.

 With love,

Your Uncle Iroh

THE SHADOWED PAST

Those wiser than I have pointed out that looking back while trying to move forward can give you a sore neck or, worse, cause you to trip over the present and fall flat on your face. Believe me, I speak from experience. My nose didn't always look like this.

My point is, our past and the history we share—our family's history—is a great place to start this journey. I'm sure you've heard it all before, but this time, I want to sprinkle a little *Iroh* on what has come before. I want to give you my personal perspective, the benefit of my years, on events you think you know very well. I have thought long and hard about the story of Roku and how it relates to my own journey and yours, as well as what it was like growing up as the grandson of Sozin, son of Azulon; it wasn't easy, let me tell you.

There are also things about your father that I feel it's time you know. Some things may shock you, and other things you may disagree with, but all I ask is that you *entertain* the idea that I might be right and you might be slightly ill informed. At the very least, you can humor an old man and do what I say. Remember, I am still your elder!

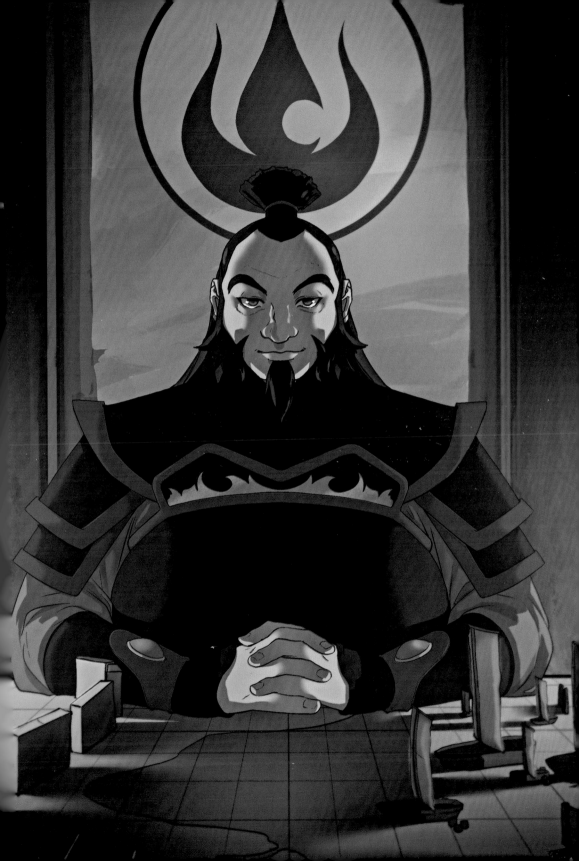

ANCIENT HISTORY: ROKU AND SOZIN

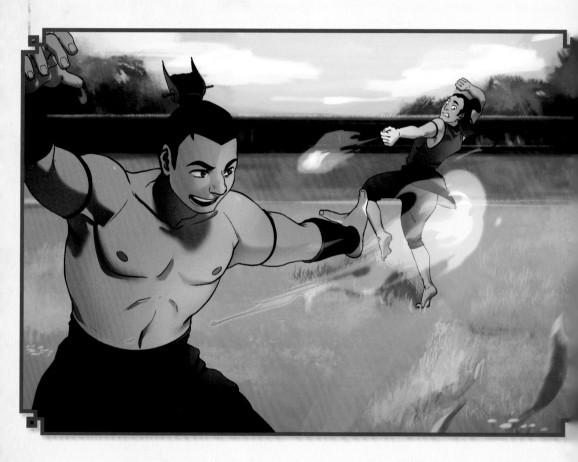

Here is the wisdom of history: It lies. It is said that history is often written by the conquerors, not the conquered, but even that is a matter of perspective. Imagine the rock in the island lagoon. From one side, you can only guess what the other side might look like. You must actually walk around to the other side of the rock in order to know its true measure. But that takes time and patience, and as far as I know, there have never been any *patience benders*. Training that muscle is a struggle for most, if not all. Lucky for you, I am old, and patience accrues with age, allowing me to see old stories through a new lens.

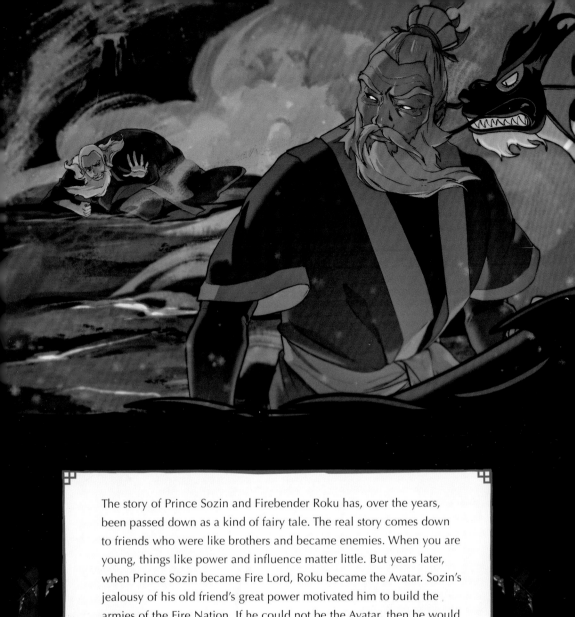

The story of Prince Sozin and Firebender Roku has, over the years, been passed down as a kind of fairy tale. The real story comes down to friends who were like brothers and became enemies. When you are young, things like power and influence matter little. But years later, when Prince Sozin became Fire Lord, Roku became the Avatar. Sozin's jealousy of his old friend's great power motivated him to build the armies of the Fire Nation. If he could not be the Avatar, then he would take power over all the nations by force. And when his old friend needed him most, Sozin left Roku to die.

Later, Sozin used the powers of the great comet to fuel the Fire Nation's invasion of the known world. It was Sozin's pride that began the Hundred Year War. That ancient rivalry born in brotherhood would later influence my relationship with my own blood brother, your father, Ozai. I often fear that the generations-long infighting in our family is the only real legacy of the Fire Nation—a legacy I believe you are here to rebuild.

Sozin and Azulon

My dear prince, the pressure you felt, and still feel, from your father and our family line reminds me so much of my own time as a young man, then soldier, then general. There was joy, to be sure, but only the joy you can get by being too young to see the pain outside your own walls. There was heat but no warmth growing up in the womb of the Fire Nation. Being the grandson of Sozin and the son of Azulon meant being born into a world of war.

 War, destruction, desolation, subjugation of all other peoples—these were part of the *family business*, and as a young man, all I wanted was to please my grandfather and my father. It would be many years and I would lose much before I realized that their unquenchable thirst for power and violence could not be sated, and their plan for my life did not have to be my story. I could choose not to honor their ferocious legacy and instead make my own way in this world. And it was in you, Zuko, that I finally saw a chance to change the course of our family line and give you the life that I could not give my son, or even myself.

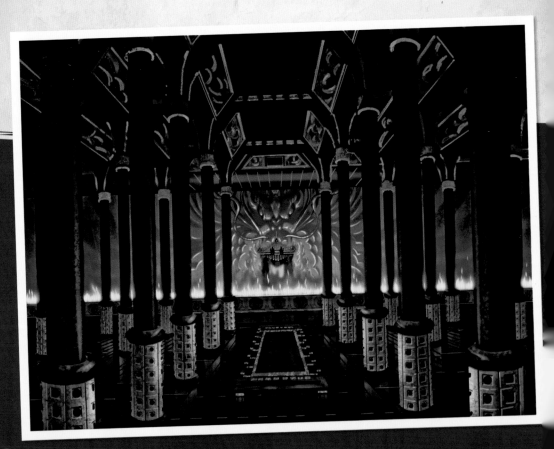

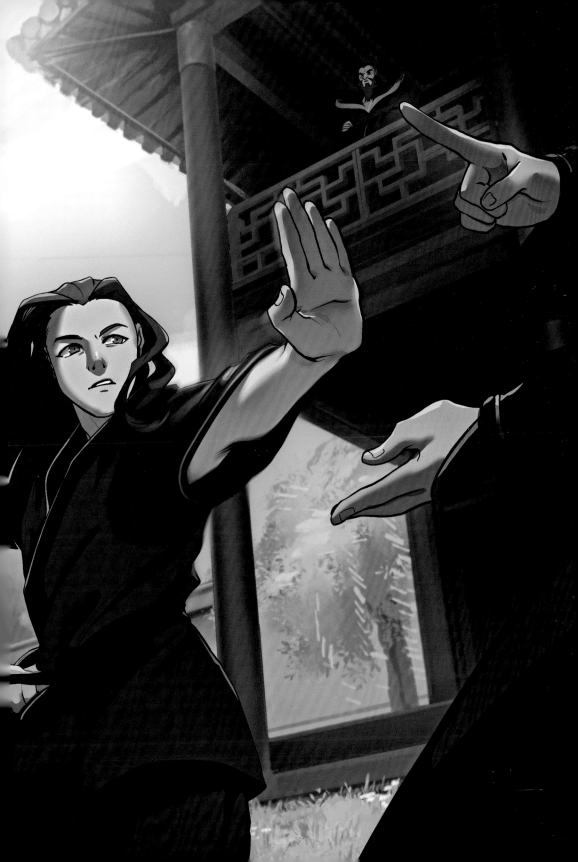

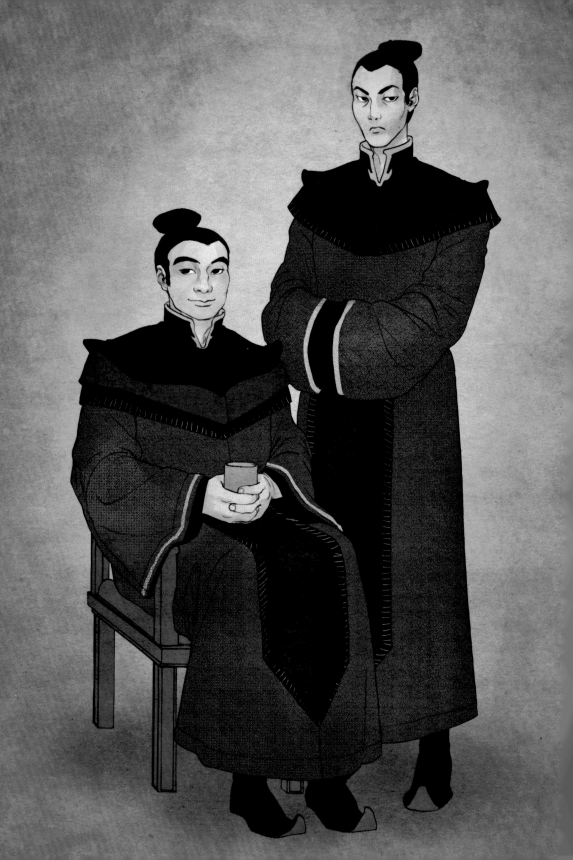

MY BROTHER OZAI

My dearest nephew, I know I don't speak often of your father, but the deepest scars take the longest to heal. Believe it or not, reopening old wounds over tea is not my favorite pastime. But you deserve to know more.

From the day your father could crawl, the fire in him burned bright. He was stubborn and impatient. It seemed like nothing could slow him down—not even me. As we grew up, we grew competitive, as brothers do, but his ambition was often greater than my own. We would fight like warriors over games of Pai Sho, where he would grow frustrated and, in fits of rage, flip the board, spilling the pieces in the air and often burning them. At first, anyone could dismiss his fury as little more than temper tantrums, but I worried it was something worse than just an impetuous heart.

In school, he showed ruthlessness that I envied, for a time. But the older we got, the clearer it was for me to see that one day we would all get burned. The fire in our people, the fire in your father—and in you—has the ability to provide warmth, inspire community, and sharpen the spirit. When unbidden and untempered, however, it will destroy, break, and lay waste to the worlds of man. When I looked in my brother's eyes, there was only fire and ash, and in his chest, a heart of ice.

Sometimes, I blame myself. I search my past for some moment when I could have reacted differently or been a better guide for my brother, but looking back instead of forward is a fool's errand, and I am too old to play the fool.

There have been times, nephew, when I've seen your father in you. But more than that, I've always known you would become the man I wish your father had been. There is much about my brother I wish had been different, but I will always be grateful he was here—because he brought me you.

THE FIRE NATION

I often wonder what the Fire Nation may have been if Sozin had listened to his friend Roku all those years ago. Before the war, the Fire Nation was a strong people in every way: trade, commerce, and weaponry. That spark we carried with us was like the light of a new day, touching every nation we were in contact with. We were powerful, honorable, but so stubborn. We were like children, so eager and powerful and full of life, but needing guidance.

We carried the kind of resourcefulness and resilient spirit honed only by living on volcanoes. What we lacked, however, were enlightened leaders.

The need for power burned in the heart of one Fire Lord to the next, and the next, and the next, stopping—I hope—with you, Zuko. There is more to being great than seizing power. To lead, you must step in front of your people and show them how to behave, with honor and heart, being an example as a man, or a Fire Lord.

If I had been Fire Lord in Ozai's place, I would have done things differently—or at least, that's easy for me to say now. In truth, that was never my path. Deep down, I discovered it wasn't really something I wanted. It was not my destiny to be Fire Lord. The fates had other plans for me . . . for the both of us!

SECRETS AND WISDOM

On my journey through the different nations, I have picked up a few things. I learned that it is vital to draw wisdom from many different places. These tips and tricks and insights helped influence my own approach to firebending. I may have also invented a few of my own moves!

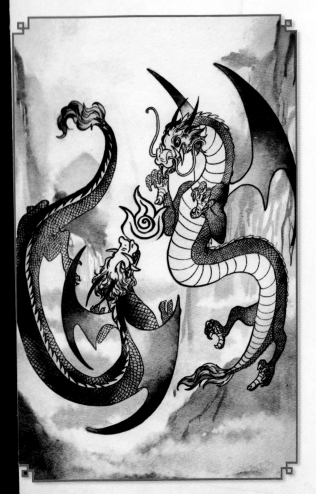

THE DRAGON OF THE WEST

A good deal of my knowledge and insight comes from studying under the Sun Warriors and the last of the dragons. They are called Shaw and Ran, and they were patient with me. One dragon was red, the other blue, but both taught me temperance in all things, using their great and ancient bodies to form the *taijitu*, the universal form of yin and yang: balance.

The Sun Warriors themselves showed me new breathing techniques, but the most exciting thing they taught me was breathing fire! I was belching smoke for months afterward, but it was worth it. Quite a party trick, let me tell you!

I was later called the Dragon of the West for slaying the dragons. Only, I didn't. Remember what I said about history? I lied! I said I killed them in order to protect them—so the world would leave them in peace—but you may already know that. Just remember, I am tricky that way.

BENDING AND BREATHING

The single most important thing I can teach you is peace of mind
anything, that is the key to enlightened bending. We are often
own way and we don't even realize it, like a boulder damming
home. Fire burns, but it—and our anger—often gets in the w
fire's master, merely its humble guide.

 This path helped me to discover bending and creating lightning.
breathing and connecting with how we allow the energy of our body to
and out. Breathing in and out. You know how to breathe instinctively, but you
must relearn the release and guidance of your energy. That is how to direct the
lightning. You are the vessel for power; you are not the power itself.

*Secret
Firebending Forms*

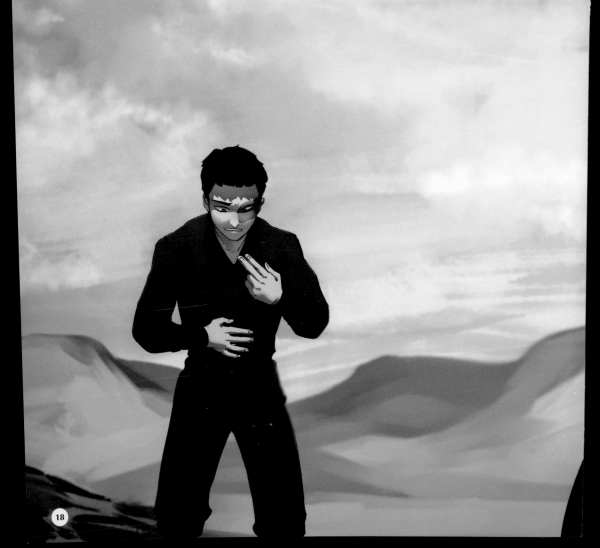

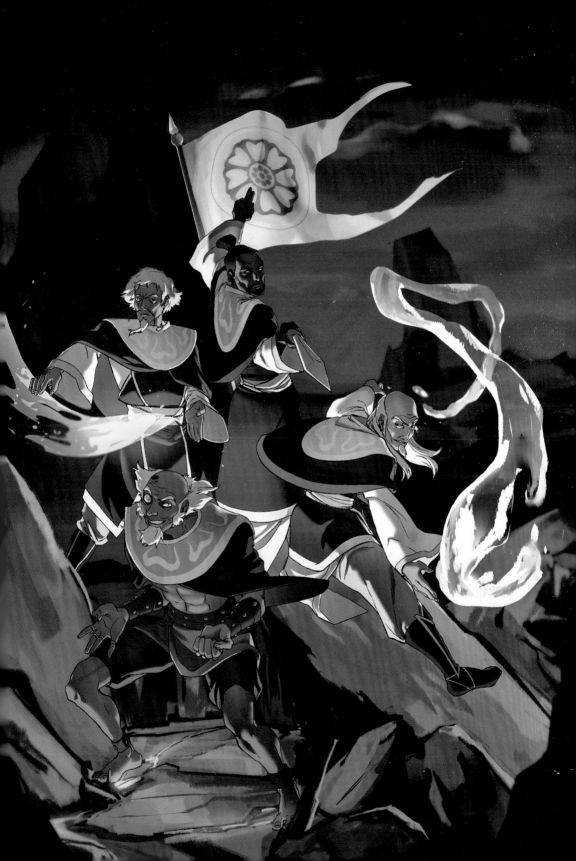

SIEGE OF BA SING SE

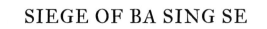

For any other soldier, the Siege of Ba Sing Se would have been career-making—no, history-making—but for me, that terrible day was both something worse and something better. Fire-hearted warriors will claim that having no loved ones makes you a fiercer fighter, but in my experience, it is the opposite. For six hundred days, my armies and I laid siege to this beautiful city, until we finally breached its great wall. But the moment of my greatest military victory was also my greatest defeat, as nearby, my boy, Lu Ten, lay dying.

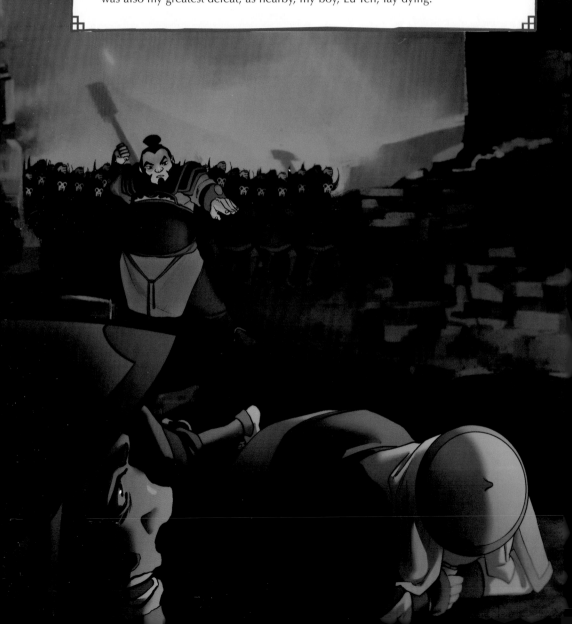

War comes with a heavy cost. I just didn't know how high until that dark day. It cost me my pride, my place in my nation and in my own family, and worst of all, my son. The man I used to be—heir of the Fire Nation, general of its armies, father of Lu Ten—all died that day on that field of battle. I thought I had nothing left to give, that my life was over. But I would discover the biggest adventure was yet to come.

I was reborn that day; I just didn't know it yet. The fates were setting me on the path to enlightenment and the path to you, Zuko. Most warriors, most fathers, most men for that matter don't get a second chance at anything, let alone their lives. But thanks to you, Zuko, I got so much more than that.

OZAI AND THE CROWN

There is something contagious in war. In my days as general, I too caught the virus of power and was drawn into the madness of battle. The mantle of Fire Lord was in my blood, and it boiled with desire. As firstborn, I was in line to become Fire Lord, but that honor was taken from me by your ambitious father. Even now, I can picture the path not taken: Iroh, the Fire Lord, scourge of the Fire Nation! How the world would fear me! But no, after the loss of my own father, and my son, my spirit wouldn't allow it, and the fates intervened on my behalf. Not succeeding my father as Fire Lord was a great gift that, at the time, felt like a tremendous failure. But now, time has taught me that this loss was the greatest gift I could have ever received. Sometimes, knowing what you really want is not as important as getting what you need.

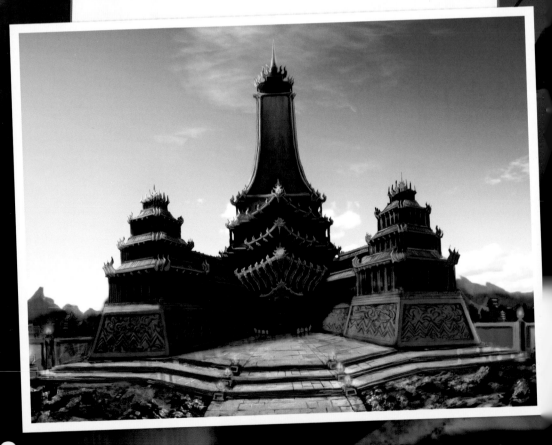

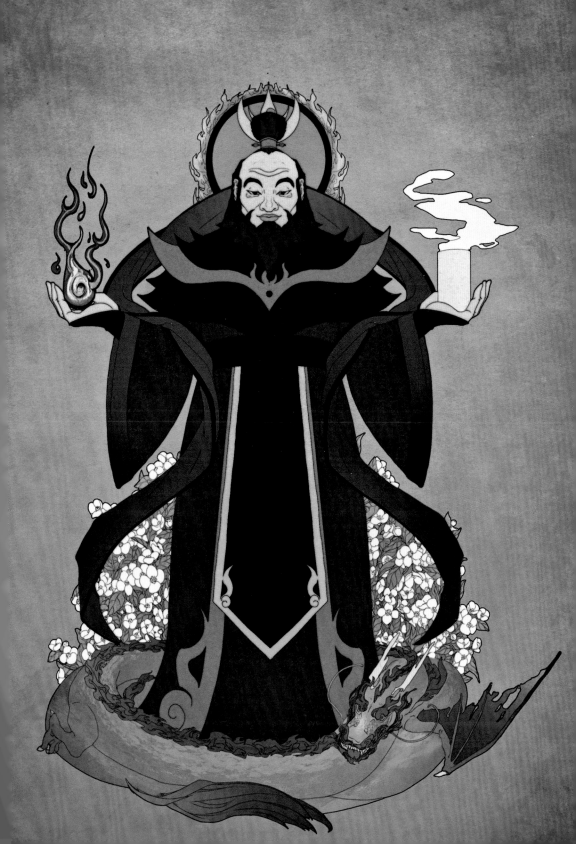

LOSING LU TEN

The greatest losses can also break you. But they can also remake you. Losing my son, your cousin Lu Ten, changed the course of my entire life. You know this already. What you may not know is that my time in the Spirit World, hoping to connect with my son, was sadly unsuccessful. I never found Lu Ten. Instead, I discovered myself. It was there that I renewed my passion for life. I would no longer be a general who took life; I would strive to be an enlightened uncle who embraced it.

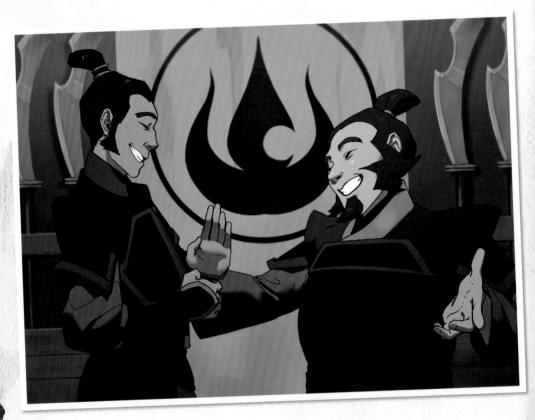

That new lease on life led me to you, my prince. What I lost in Lu Ten I gained in you, Zuko. Because I cared about you and your journey, because I gave of myself, my chi grew and so did my heart. You gave me a second chance to be the kind of father I always wanted to be: free of the chains of the Fire Nation and instead working for the good of all nations, starting with you. You are a gift in my life, Zuko, and I am so honored to be your uncle. I hope this part makes you cry. Just make sure you don't cry on this ink; it will run and then so will all of this wonderfully poetic sentiment.

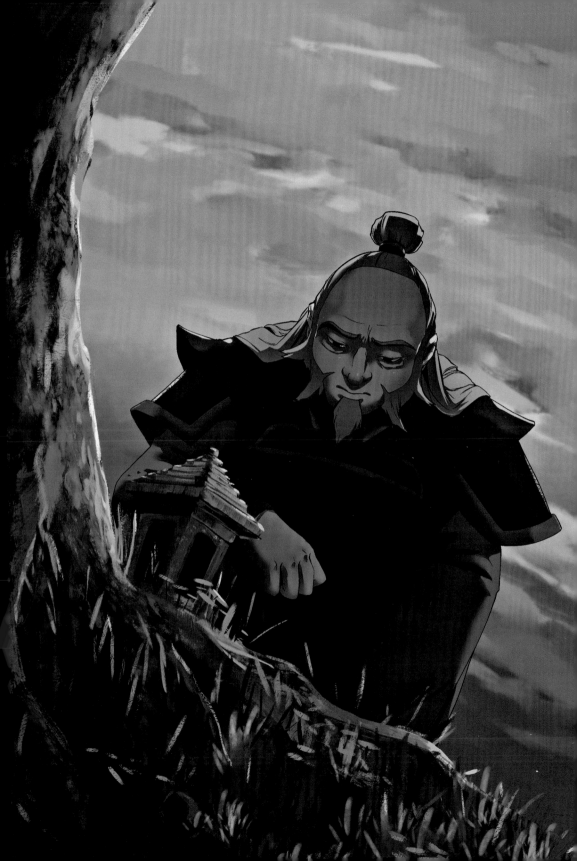

THE JOURNEY

FIRE BETWEEN FAMILY

There is an old problem that runs in our family, Zuko. It is a vein of harmful favoritism—something in our blood that makes these ties that bind burn and scald as they keep us close.

It goes back to Sozin and Azulon, and in your own family, I saw how your father was often favoring Azula over you. You struggled to save face with your own younger sister, and the fire and rage of her competitive spirit threatened to bring you down utterly. It was like Ozai and myself; our rivalry diminished our familial bond until all that remained was the pain. Your father could have intervened, but he was blinded by the fury, the same fury he saw in his own heart. He was too busy lauding your sister and waging war on the world to give you the time you deserved.

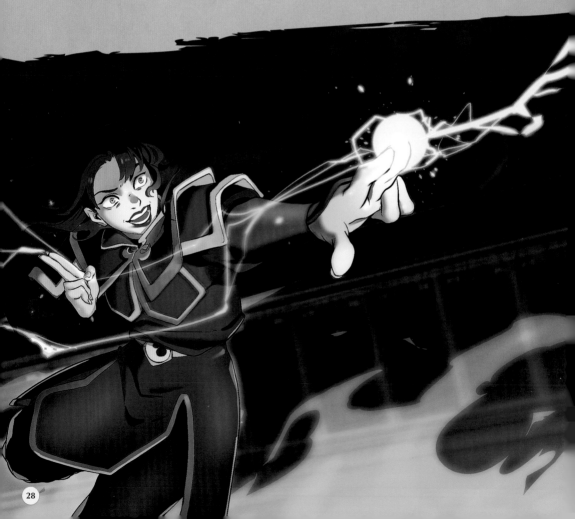

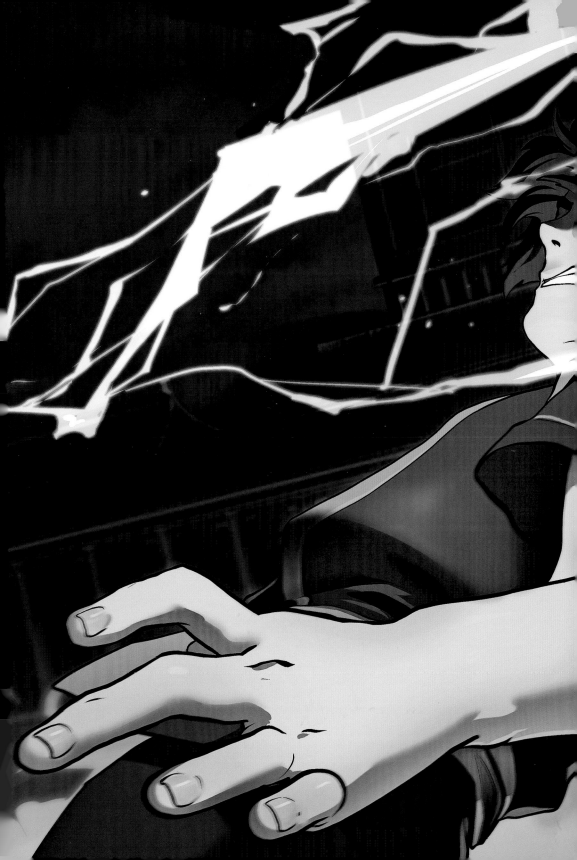

It was hard for you when you believed your mother was gone, and I saw you struggle with your own firebending abilities as, slowly but surely, your younger sister's bending skills surpassed your own.

There may have been a time when the Agni Kai was a useful tool to settle disagreements between ancient Firebenders, but in our world, I find it difficult to see it as anything but a brutal and barbaric tradition. In your own life, the Agni Kai tore you from your father, your nation, and finally your own sister. It's easy to say that those wounds were tragic, but in my estimation, they were your passage into manhood, setting you on the path to becoming the good man and great leader I know you to be.

Sozin

Azulon

Iroh

Ozai

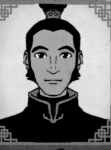

Lu Ten

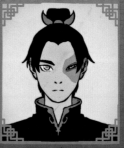

Zuko

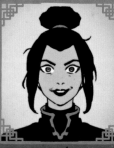

Azula

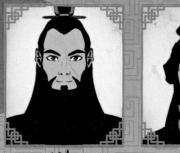

Roku Tamin

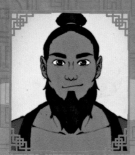 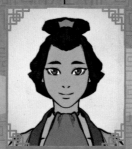

Jinzuk Rina

Ursa Ikem

Kiyi

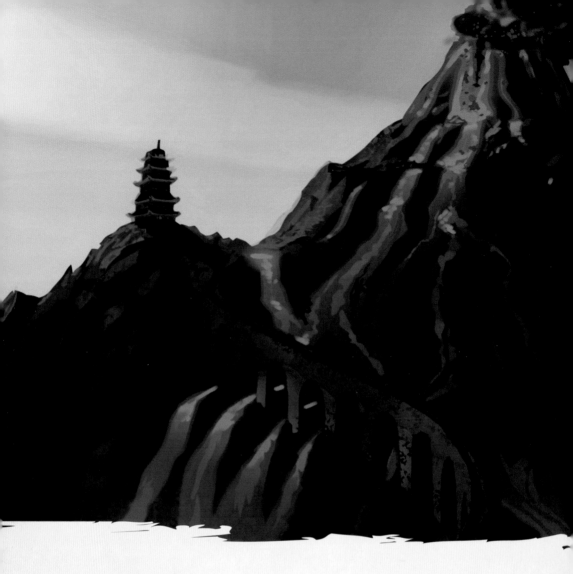

The Agni Kai with your father merely proved what we all sensed: that Ozai was without love. He did not deserve you as a son. Your banishment was a punishment, yes, but also a chance to move forward on your own journey, instead of on the path your family wanted for you.

The Agni Kai with Zhao initially showed me your immaturity, but when you spared him, you showed me your heart. I saw the heart the Fire Nation needed but did not deserve. And finally, in your confrontation with your sister, you were a true warrior. Only that time, you were mature, balanced, and breathing. At peace. You grew up. And then, your heart burned brightest when you protected Katara. The fire of that friendship—that bond—that is your strength, my prince. Each time you faced the Agni Kai, more and more of you was peeled back, until your true self was revealed: Zuko the hero, as you were destined to become.

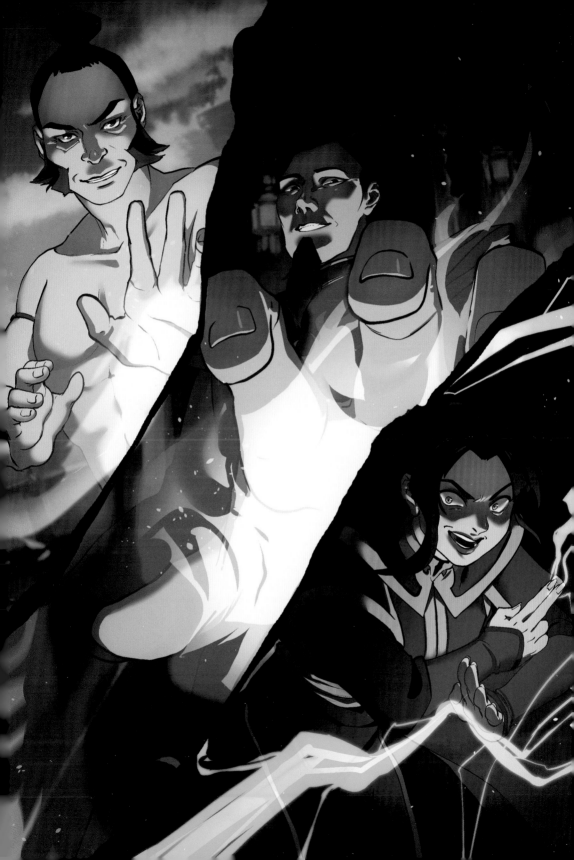

TRAVELS WITH ZUKO

And now we come to you, dear Zuko, and where our paths crossed for the great adventure we shared. Like most stories, it started small, and a beginning is a very delicate time. But like any story, it is neither the beginning nor the end that truly matters; it's the journey.

Those battles you faced, your Agni Kai and others, showed you and the world who you really are. The quest you went on in search of the Avatar was never about Aang. Like my journey to the Spirit World, your journey was about the hunt for *yourself*, your inner self. Your true self. And with Team Avatar's help, you showed the world what the future of the Fire Nation looked like and saw your true face for the first time.

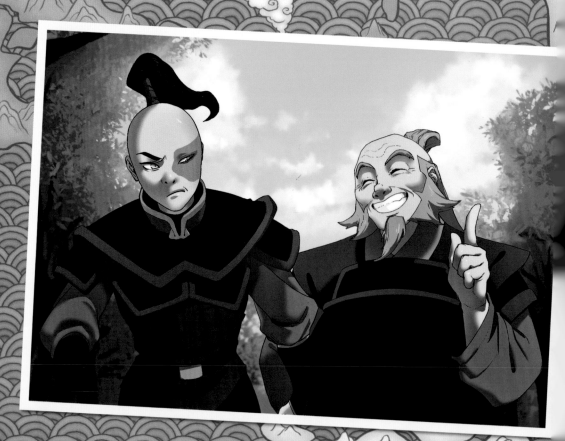

Our time together stretched and pulled at our relationship. Whether we were stuck in the desert, or you were grinding your teeth in your sleep, or we were living through your relationship with Mai, you and I stood together and walked a deadly, extraordinary, hilarious, and legendary path.

There is nothing I would trade for that time. I will always look back on it as the best time of my long life. And I hope you feel the same. If you don't, you are a heartless statue and your punishment shall be the tea you make yourself.

TEAM AVATAR

A wiser man than I once said that every person who comes into your life is there for a reason—some are there to guide you, encourage you, or work with you as allies. Others can be antagonistic and will test you or even grow into your enemies. It's very rare for these people to become both or all of the above, but the self-titled members of Team Avatar certainly fit the bill. When you were young, reckless, and angry, you needed a tangible antagonist for your fury, and Team Avatar was there. As you matured, and your paths continued to cross, your evolution and theirs became the same journey. Though, I hasten to add that, at one time or another, you may have needed them more than they needed you. But history will decide that without help from me.

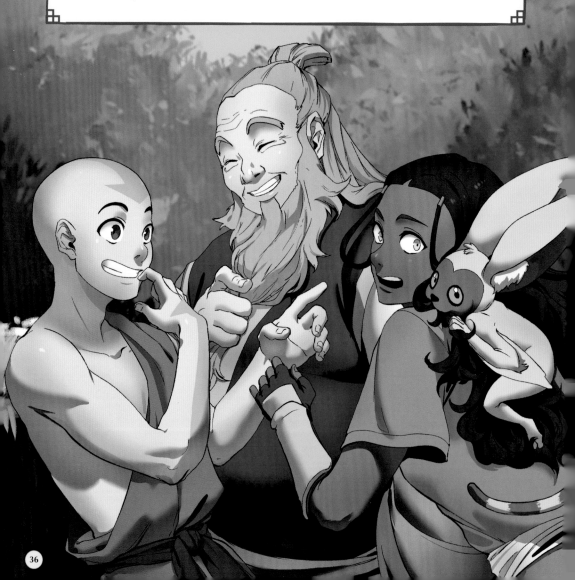

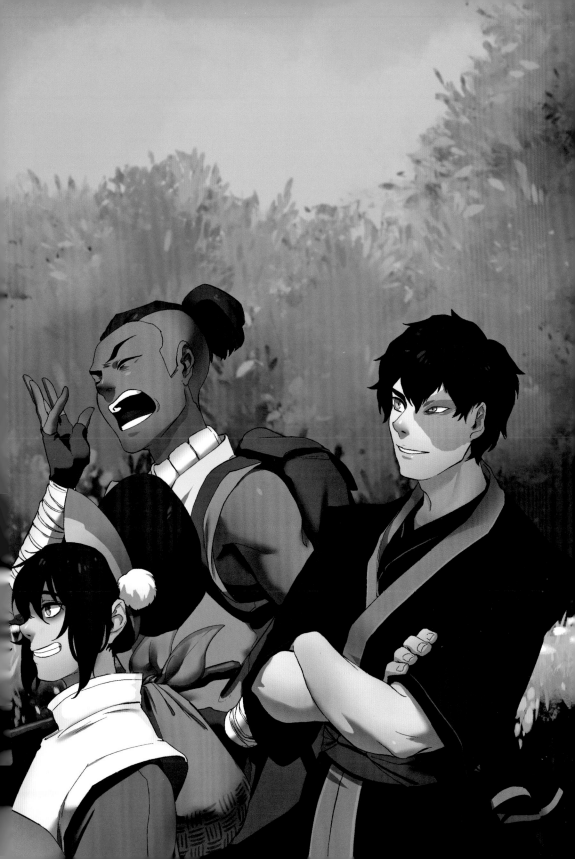

KATARA

Outside of the Avatar himself, young Katara always struck me as the most powerful, if undisciplined, bender of the age. She certainly was the whetstone against which you honed and sharpened your fury, at least for a time. You both shared tremendous passion but also emotional pains that fueled the fires in your bellies. More than any other member of Team Avatar, Katara forced you to grow up, pushing you to become the man I knew you could be.

Sometimes I thought Katara's feisty fire burned brighter even than yours, Zuko. And hers was never so hot as when she blamed you for the death of her mother. But it was your heart, again, in its desire for forgiveness that prompted you to reach out and help seal the wound in Katara's by seeking out the ones who had committed that crime.

In your pursuit of the Southern Raiders, Katara's thirst for revenge was almost her undoing. But her instincts and Aang's advice served her well, as she discovered that vengeance was not the answer. And while she was not able to forgive the pathetic excuse for a man who took her mother away, she was able to forgive you, my prince. And it was there that something beautiful grew from grief: a friendship built on the bonds of warriors united in heart and cause—the blossoming of true trust.

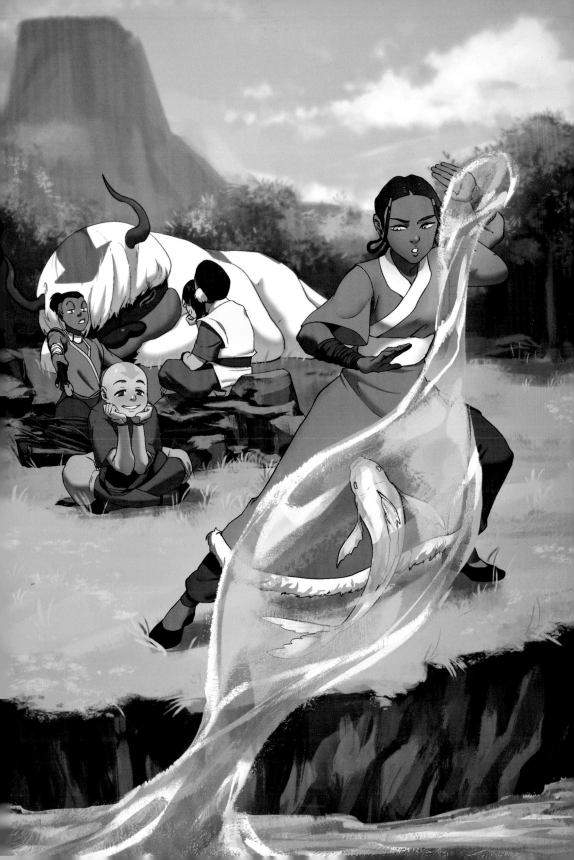

SOKKA

I never considered sarcasm a natural element—until I met Sokka, that is. If what comes out of that boy's mouth is not considered a special type of bending, I don't know what bending is. At first, I would have dismissed Sokka as the weakest link in Team Avatar as he had no elemental powers. But it was his bravery and heart that gave his friends their strength, and in turn gave you an example of how friends could be your advocate in life and an asset in battle.

The prince and the fool. But is that all you and Sokka were, or were to one another? No, I think not. There, see? I got to answer my own question. One of the many joys of writing this to you. Well, that and I don't have to hear your back talk. But talking is most of what Sokka is: a mouth on legs. That gets him into plenty of trouble on its own. But it was when Sokka chose to *act* that you both got in over your heads.

His fool desire to save his father from the bowels of Boiling Rock prison without a plan, without help—it was only you who knew what Sokka was trying to do. And you stepped up. Sokka was brave enough to do something stupid for someone else, but he needed you, Zuko, to remind him that being brave can mean failing. Your experience with failure and your refusal to give up helped Sokka when he needed it most. And maybe you needed a bit of his foolhardy spirit to remind you that you are human too and that trying to do the honorable thing doesn't always mean doing the *right* thing.

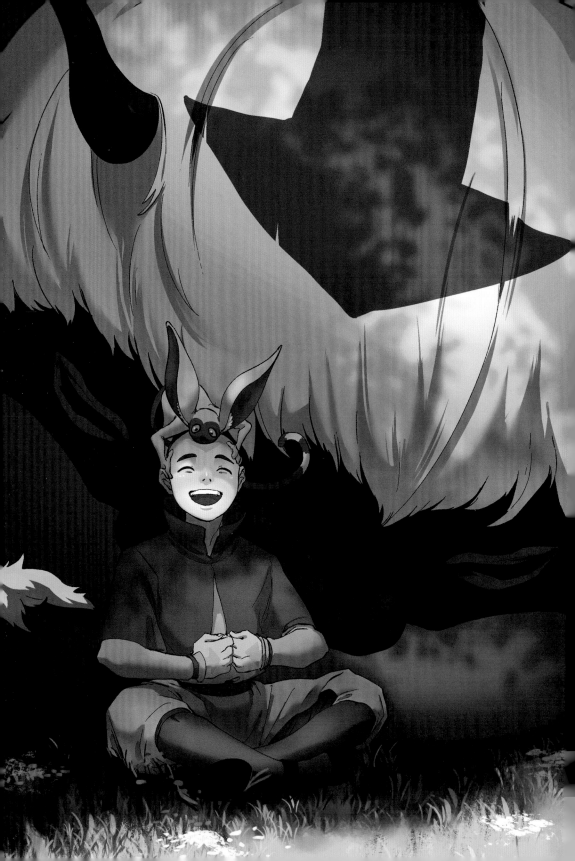

AANG

Aang was a puzzle to me, for a time—a wayward child one moment and savior the next. His emotional temperament sometimes got the better of even my patience. He was such an unpredictable young man. As your prey during your hunt for respect from the Fire Nation, Aang represented the key to what you hoped was validation from your family.

But when the time came, it was Aang and his friends who finally gave you the acknowledgment you so desperately needed. Aang's wild youth and powerful spirit moved you in ways I could not and helped to change your path, and your heart. Before you helped him save the world, he helped save you, my dear prince.

Seeing with different eyes can often give us a perspective on the world, or on people, we may have been blind to. And it was your adventure with Aang, when your face was hiding behind the mask of the Blue Spirit, that first gave you new eyes with which to see the Avatar.

Until that day, the Avatar was your prize, and after that day, Aang, with his bright spirit and selfless heroism in the face of danger, was so much more. He did what I couldn't do: He made you doubt that the world was black and white and showed you that maybe your enemy could be an asset at worst, and your friend at best.

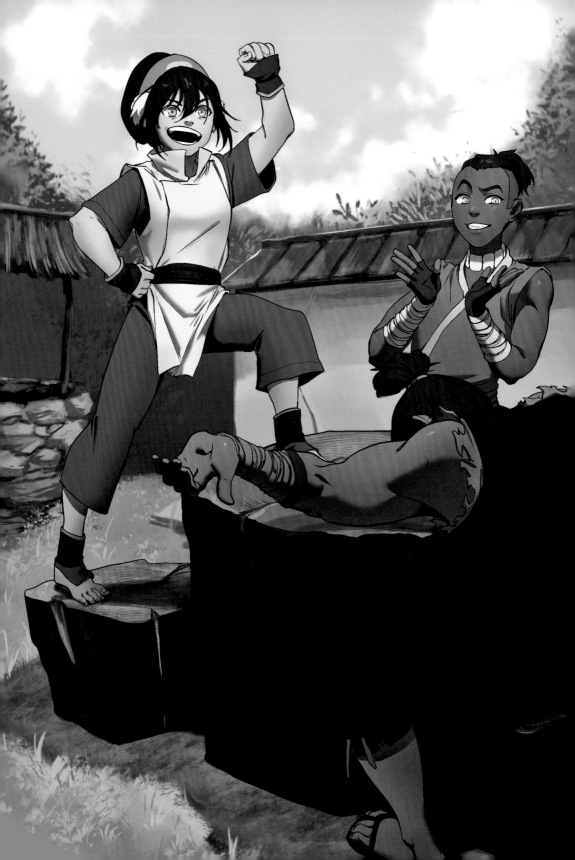

TOPH

Toph was a fierce warrior, and I always thought that out of every
member of Team Avatar, she was your match for fighting spirit.
Your stubborn thick-headedness had finally met its equal in that
ferocious warrior. It was easy to peg her as a wild card, reckless
and out of control, but I think that blind girl showed you more
than you could see with your own eyes; she was a mirror for your
behavior and an example of how to grow beyond your perceived
shortcomings.

 If memory serves, you never had a "life-changing field trip" with
Toph as you did with the other members of Team Avatar. Looking
back, I wonder if that was for the best. I imagine that forcing
together your spark and her metal would be just as explosive as
her fire and your mettle. Maybe that particular combustible story is
best left untold, eh?

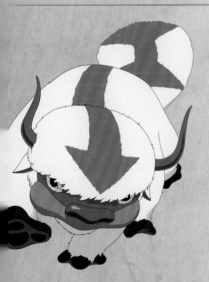

APPA

It was Appa whose very presence instigated a seismic change
within you, my nephew . . . not without some *gentle* prodding
from myself, of course. When you went to capture that sky
bison under Lake Laogai, you stepped back onto the wrong
path—the path others had set before you. You weren't thinking
things through then, but once I challenged you, I saw you
shrug off the shackles of a destiny others had forced upon you
and start your own journey, looking inward and asking the big
questions like, "What do I want?" It took a *big* sky bison to get
you to focus on those big questions.

MOMO

Of course, I would never want to leave out a very important
member of the team, which brings me to Momo, that little winged
lemur! Like Aang himself, Momo seemed to represent the spirit of
the lost Air Nation: Full of life and, sometimes, heroic instincts, he
was a holdover from a different age who brought joy and comfort
to our trials. He was also awfully cute, wasn't he?

Dear General Iroh,

Long ago, you were my enemy. And then, you were my friend. Now, looking back, I see that you were so much more. Almost every time we met, whether you were on my side or not, you seemed to be doing the right thing, and you were always focused on leading Zuko by example. The way you fought for the life of the Moon Spirit and saved us in the Crystal Catacombs . . . Every time, you did the honorable thing—even when it caused you bodily harm, as it often did when we ran afoul of your niece, Azula.

When you guided us through our final confrontation with Ozai, and I elected to support Zuko in his battle against Azula, you encouraged me. That alone told me that I was doing the right thing, because the right thing was all Iroh ever did. If you approved of my actions, I knew beyond a shadow of a doubt that I was doing the right thing. That gave me confidence to help my friends and do the impossible. I could not have done that without you.

Thank you, dear Iroh, for always being exactly who I needed you to be.

Oh yes, and I so miss your incredible tea!

Gratefully, Katara

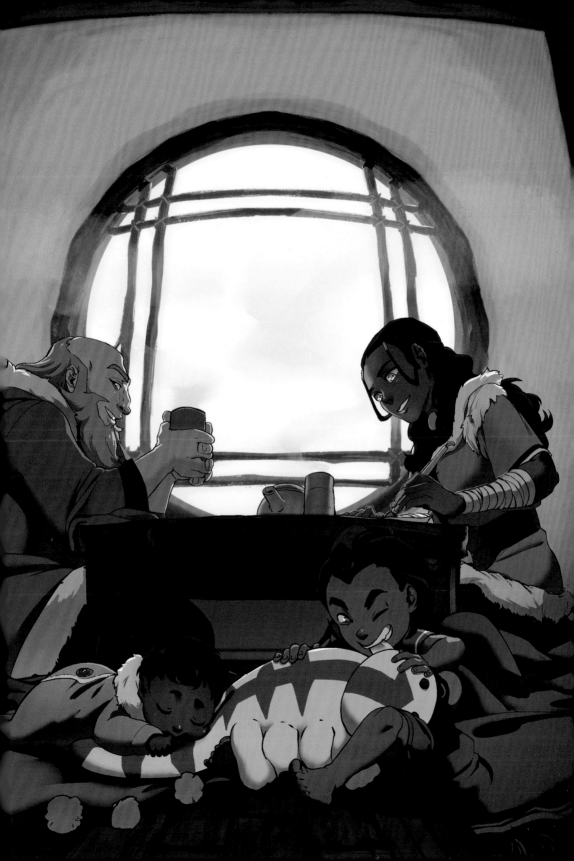

Iroh,

Katara is writing this all down for me because—hello, I'm blind.
You're very powerful, for an old man. I'm not sure what's stronger,
your puns or your bending. Thanks for the tea.

Toph
aka The Blind Bandit

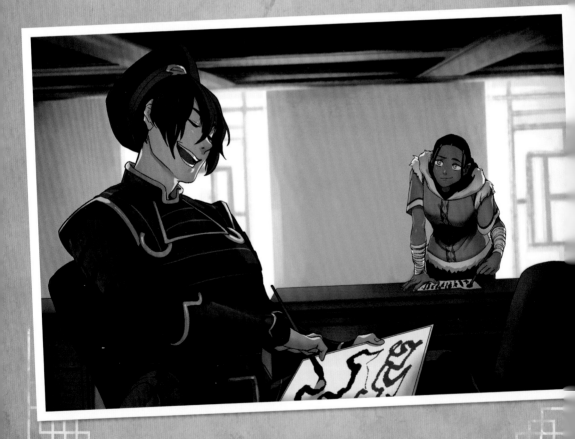

Hey Zuko's Uncle Iroh,

Katara's making me write this letter because she thinks she's our mother. Anyways, you're pretty funny, for an old guy. And you're pretty old, for a funny guy. Please stop making me drink your tea. Thanks for helping us out and being old or whatever it is Katara wants me to thank you for.

 Signed, the leader of Team Avatar for life, no take-backs, no erasies, Sokka.

 P.S. Are you <u>sure</u> there's no bending for jokes? Or how about bending for gas? Or is that just <u>breaking wind</u>?

Dear Master Iroh,

I should have written this letter long ago. More to the point, I shouldn't be writing it at all—I should be telling you this in person. Have you ever noticed how gratitude looks so small when its just words on paper? But thank you. Thank you anyway. And thank you again! Thank you for sticking with Zuko the way you did, because if you hadn't, we would never have met, and without you, I'd never have learned firebending and become the true Avatar. You helped me grow. Without you, I'd never have stopped Ozai. Without you, this world would be ashes and soot. You're like, the greatest bender teacher that there is! And you make great tea.

I haven't had a real family in a very long time, and you became like the uncle I always wanted. I know for Zuko you are that and so much more. I hope that, with your guidance, Zuko is able to reach his full potential. There is greatness in him. I've seen it. His heart burns brighter than any flame we can bend. With you at his side, I believe Zuko can become a great Fire Lord, and together the two of you will create a truly honorable and righteous Fire Nation.

Aang

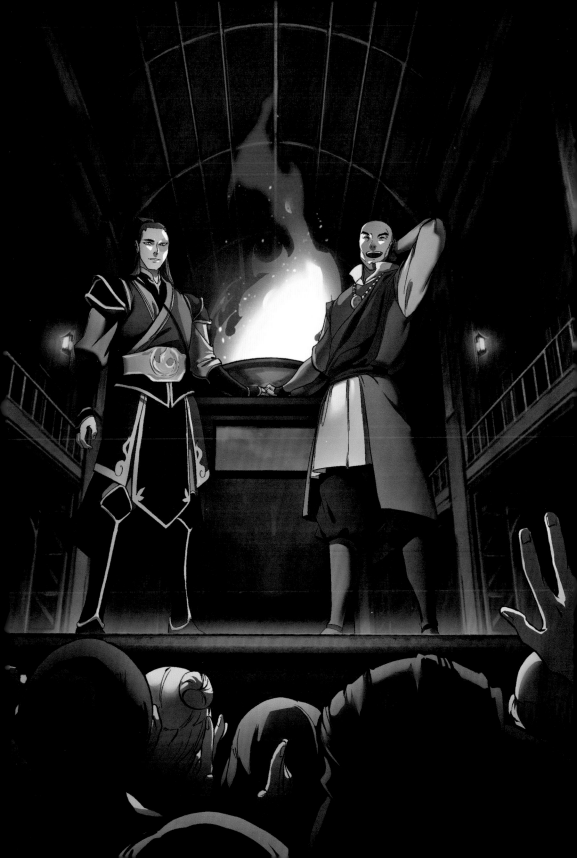

THE JASMINE DRAGON

My prince, you are a good man and a great warrior, but it's time I told you my most closely guarded secret—you make terrible tea! I don't tell you this to discourage you.

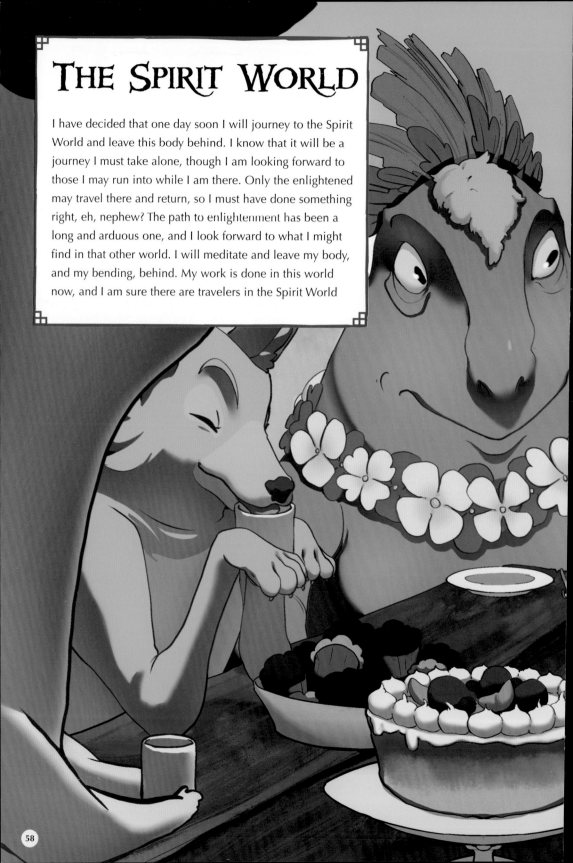

THE SPIRIT WORLD

I have decided that one day soon I will journey to the Spirit
World and leave this body behind. I know that it will be a
journey I must take alone, though I am looking forward to
those I may run into while I am there. Only the enlightened
may travel there and return, so I must have done something
right, eh, nephew? The path to enlightenment has been a
long and arduous one, and I look forward to what I might
find in that other world. I will meditate and leave my body,
and my bending, behind. My work is done in this world
now, and I am sure there are travelers in the Spirit World

whose chi needs my tea! My spirit has taken brief trips there before, but my grief and connection to this realm have pulled me back. Once, I traveled there to speak with my son, but I have since learned the Spirit World is not exactly the realm of the dead. There are free spirits, and dark spirits, and animal spirits in this world. Most living humans should never travel there, but I am *not* like most, as you well know. There is a fog there, a prison for lost souls, but I trust that will not occupy my time while I travel in that world. Food does not add to the weight of your spirit there, something I am greatly looking forward to. But they have no bathrooms in the Spirit World, and I look forward to that *less*. I picture it as my last great adventure, and I almost wish you were coming with me, but I know you have much good left to do here in this world. Your work is not done, my nephew.

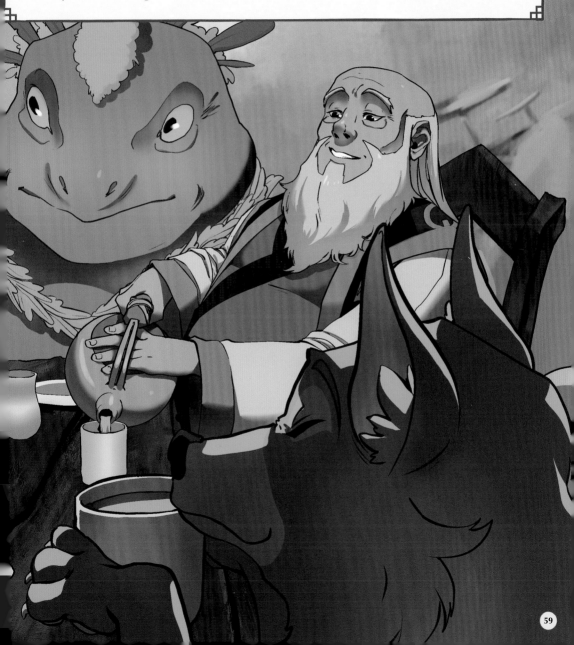

Fire Lord Zuko,
I have never written a letter quite like this one, because I actually haven't written this letter at all—your Uncle Iroh did. Recently, I spent some time in the Spirit World and I met your uncle. Even as a spirit, he remains a charming and honorable man. He spoke very highly of you. He also made an exhaustive number of jokes. Your uncle also asked if he could dictate a letter I could bring back to you, and it was my honor to oblige.
 Be well,
 Korra

My Dear Prince,
Boo! I am writing you a letter from the Spirit World! I am so scary! I will haunt you for all your days! (From Korra: He made me write that.) I kid, I kid. Here I was, minding my own business in the Spirit World, when who should I meet? Why, the next Avatar! She's a plucky young Waterbender named Korra, and I convinced her to write this letter for me.

One of the few disadvantages of being in the Spirit World is not being able to write anything down. It is quiet here. So quiet. At first, it took some getting used to, but humming or singing a tune helped. Now I know that quiet to be a sign of peace-peace like I never felt before I got here. I do find my heart and my thoughts turning to you, my nephew, from time to time. I just wanted you to know that even here, you are with me. And I hope you know I am still with you. I have found joy here and have reunited with many who went before us. It is better than I could have dreamed. But I have not cut myself off from the old world quite yet.

I hear the world, your world, is changing, moving on, moving forward, as I know you are. And it brings me such joy to think of the life you now live. Put this in that journal I gave you, and when you miss me, you can read these words. Now, if you'll excuse me, there are vexing spirits here who owe me a game of Pai Sho!

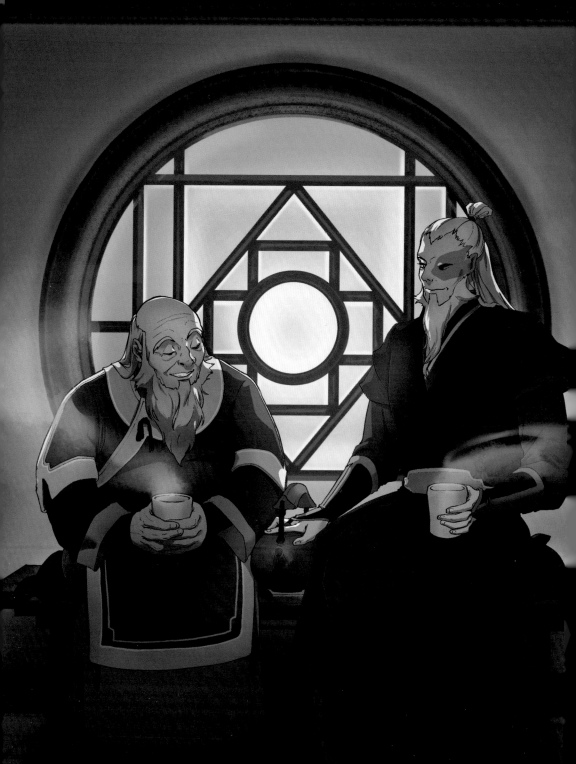

HOPE FOR THE FUTURE

Zuko, this is likely the last entry I will make in this journal. I could never tire of the sound of my own voice, but I do know its silence will signal something better: the future! In my very first letter to you, I was only half joking when I called this book the Legacy of the Fire Nation. You, Zuko, and the choices you make going forward, not the ramblings of an old man, are the true legacy of the Fire Nation.

The past, like the treasured memories of my time with you, are ashes on the wind, nothing more. The only fires worth keeping alive are the ones we light for the future, for our children, nephews, nieces, and grandchildren. As I prepare to move to the Spirit World, I trust you to that good work, my prince. I will miss your voice and your face, my nephew, but know that I am proud of you and always have been.

With love and admiration,

Your Uncle Iroh

P.S. The more you practice your Pai Sho, the better you will get at it. Probably. But, maybe it's just not your game . . .

INSIGHT EDITIONS

PO Box 3088
San Rafael, CA 94912
www.insighteditions.com

Find us on Facebook: www.facebook.com/InsightEditions
Follow us on Twitter: @insighteditions

Library of Congress Cataloging-in-Publication Data available.

ISBN: 978-1-68383-392-5

Publisher: Raoul Goff
President: Kate Jerome
Associate Publisher: Vanessa Lopez
Creative Director: Chrissy Kwasnik
Designers: Evelyn Furuta and Megan Sinead Harris
Senior Editor: Amanda Ng
Editorial Assistant: Maya Alpert
Managing Editor: Lauren LePera
Senior Production Editor: Rachel Anderson
Senior Production Manager: Greg Steffen

Illustrations by Sora Medina

ROOTS of PEACE REPLANTED PAPER

Insight Editions, in association with Roots of Peace, will
plant two trees for each tree used in the manufacturing of
this book. Roots of Peace is an internationally renowned
humanitarian organization dedicated to eradicating land
mines worldwide and converting war-torn lands into
productive farms and wildlife habitats. Roots of Peace will
plant two million fruit and nut trees in Afghanistan and
provide farmers there with the skills and support necessary
for sustainable land use.

Manufactured in China by Insight Editions

10 9 8 7 6 5